How to Master Still Life Painting in 24 Hours! A Seven-Step Guide for Oil Painting a Still Life Today

By: Jeremiah Jolliff

How to Master Still Life Painting in 24 Hours! A seven-Step Guide for Oil Painting a Still Life Today
Jeremiah Jolliff
www.ArtworkByJJ.com

Copyright (C) Jeremiah Jolliff 2015. All rights reserved

ISBN-13: 978-1517439491

ISBN-10: 1517439493

Jeremiah Jolliff is a fine artist from Ohio in the United States.

Today, Jeremiah works with artists and entrepreneurs from around the world, helping them to successfully create, publish and promote their work.

Jeremiah's primary focus is helping artists and entrepreneurs strategically position themselves. Achieving rapid growth of business by attracting ideal clients and charging higher fees.

This book is dedicated to the artists who labor in solitude.

Failure is not an option.

"I dream my painting and I paint my dream."
 -Vincent Van Gogh

"However one's mind may be elevated, and kept as to what is excellent, by the works of the Great Masters, – still Nature is the fountain's head, the source form whence all originality must spring."
 -John Constable

"All you need to paint is a few tools, a little instruction, and a vision in your mind."
 -Bob Ross

"Builders and warriors, strengthen the steps. Reader, if you have not grasped — read again, after a while. The predestined is not accidental; the leaves fall in their time. And winter is but the harbinger of spring. All is revealed; all is attainable."
 -Nicholas Roerich

"The great secret of Freemasonry is that there is no secret at all."
 -Benjamin Franklin

How to Master Still Life Painting in 24 Hours! A Seven-Step Guide for Oil Painting a Still Life Today 1

Introduction 7

Chapter 1 How to Prepare Materials 11

Chapter 2 How to Draw a Still Life 29

Chapter 3 How to Transfer a Still Life Drawing 33

Chapter 4 How to Complete a Color Study 39

Chapter 5 How to Start the Painting 43

Chapter 6 Develop the Painting Further 46

Chapter 7 How to Finish a Still Life 49

Chapter 8 A Quick Exercise and Conclusion 53

Acknowledgements 57

Further Reading and Bibliography 60

Introduction

I would like to discuss how this book came about. This book developed from a workshop I attended at the Florence Academy of Art in Mölndal Sweden. One of the Instructors specializing in Still Life was Cornelia Bauman Hernes. She is an excellent instructor and anyone interested in painting Still Life should seek her out immediately.

This book is an accumulation of workshop handouts, and extensive personal notes from the workshop. If the artist reading this book is desirous of studying art, The Florence Academy of Art is the only place for a fundamentalist.

This book is organized into seven-steps and expedites the reader into the craft of oil painting a Still Life. The first step is to gather materials and then move seamlessly into the next steps.

The reader will be relieved that this seven-step guide is easy to follow and gives the artist the working tools to produce a Still Life Painting. The purpose of this book is to save the artist time and give them direct advice without the fluff.

The journey to writing this book has been long and enjoyable. Modern art has pretty much wiped out the knowledge of the craft of painting. If it weren't for fine institutions like The Florence Academy of Art, these techniques would still be largely unknown to the masses.

For that reason, I would like to say thank you to the Florence Academy of Art.

I read many books on painting after the workshop. The artists of old, humans of great renown, were able to produce high forms of art with limited materials. During the workshop we were taught how the masters painted. It is my hope that the artist can learn to paint using traditional techniques still taught at The Florence Academy of Art.

My apologies for any typos…

If you want free tips and would like to contact me, go to my website now and opt-in: http://www.artworkbyjj.com/

All of my artwork is available for sale as originals and prints, along with painting tutorials, recommended products, and more.

My Website: http://www.artworkbyjj.com/

https://www.facebook.com/ARTWORKBYJEREMIAHJOLLIFF

Blog: https://jjolliffblog.wordpress.com/

Twitter: https://twitter.com/jeremiahjollif

Youtube: https://www.youtube.com/channel/UCsauBxqWjjow6bCKl7DgRHA

LinkedIn: https://www.linkedin.com/in/jeremiahjolliff

Google+: https://plus.google.com/u/0/+JeremiahJolliffartwork/posts/p/pub

Instagram: https://instagram.com/jeremiah_jolliff/

Pinterest: https://www.pinterest.com/jeremiahjolliff/

Chapter 1 Step 1 - How to Prepare Materials

Materials

It is overwhelming trying to figure out what to purchase for still life painting. Everyone's advice is different. Art suppliers market all kinds of materials that are unnecessary. The following is *the* definitive list of supplies required. In this chapter, I will give the complete list of items that are necessary for a successful still life. I will list the items and then give short descriptions thereafter. After the descriptions, I will describe how to prepare the materials before beginning a Still Life. Organization is a necessity. Here is a list to make it easy.

Materials list:

Sturdy Easel & Structure for the still life

18" x 24" Utrecht Master's Panel

#4 Hog Bristle Filbert Brush (2)

#3 Hog Bristle Filbert Brush (2)

#2 Hog Bristle Filbert Brush (2)

Palette Knife

Palette

Paper Towels

A container for medium

Turpentine

Linseed Oil

Stand Oil or Black Oil

Vine Charcoal & knead-able erasers

Plumb Line

Mirrors

Titanium White

Cadmium Yellow

Cadmium Red

Yellow Ochre

Burnt Sienna

Ultramarine Blue

Mars Black

Descriptions of Materials

Sturdy Easel- The importance of a good sturdy easel cannot be stressed enough. It pays dividends to have an extremely stable support upon which to paint. It is practical to build a nice "light box" out of wood. The wooden structure should be of equal height as the easel. Cover the inside of the "light box" with dark, neutral colored material and have an extra board that can be placed over the top to adjust the effects of light. If the reader is wondering what type of structure to build, rest assured there will be pictures later on in this guide.

18" x 24" Utrecht Master's Panel- an 18" x 24" Utrecht Master's Panel is the perfect size onto which a still life can be painted. The 18" x 24" captures the still life perfectly and is close to life size and thus adds to the believability of the still life. The Utrecht Master's Panel is also hand primed to a perfect lead like surface. The lead like surface is excellent to paint on and helps the artist to gauge

the values of the still life composition.

Brushes- In regards to the hog bristle brushes; it is a good idea to have two of each size. Keep one for painting light and the other for painting in dark values. Having two brushes of each size will greatly aid the artist in working efficiently. Two brushes help the artist to work efficiently because there is no need to constantly clean brushes when switching between light and dark values. Don't use sable brushes. Use the old-fashioned bristle brushes. When using the painting medium described below, the brushstrokes will disappear because the painting medium levels out when the paint is allowed to sit upon the canvas undisturbed and is allowed to dry.

Mirrors- a white mirror or regular mirror is used during the block in stage. The mirror should be small about 3" x 5". It is used by simply holding the mirror between the eyes with the mirrors edge inline with the bridge of the nose. One eye is used to look at the still life while the other eye looks at the mirrors reflection and canvas. Using a mirror helps the artist see proportions correctly. If more information is required, look up how to use a mirror in the "sight-size" method. A black mirror is handy in the later stages in order to find out the value relationships in the still life.

Plum Line- The plumb line is a piece of string with a weight on one end and is used to determine the absolute vertical line relationship in the still life. The string of the plumb line can also be used to measure distances in the still life.

Palette Knife- a flexible medium sized palette knife will do the trick. The best are tapered towards the end, are flexible and help the artist to not only mix paint on the palette but scrape out areas upon the canvas.

Palette- a palette made of wood is best. I suggest buying a medium sized palette and coat it several times with linseed oil before using it. As time goes by, the palette will begin to take on a very neutral grey color. Having a good, aged palette helps the artist to determine color & value more accurately.

Paper towels- secure a whole roll of cheap paper towels. Having a large quantity of paper towels pays dividends because they can be used for things unimaginable.

Container- There are small metal containers that have a clip on them that can be utilized to clip directly onto the palette. The container is used to hold the painting medium described below.

Turpentine- high quality turpentine is a necessity for

cleaning brushes at the end of each session. Do not buy turpenoid or odorless mineral spirits.

Linseed oil- the artist should purchase only artist's grade linseed oil.

Stand Oil or Black Oil- taken together with a high quality linseed oil makes a great medium for still life painting.

Vine Charcoal & knead-able erasers- vine charcoal erases easily and knead-able erasures can easily remove charcoal dust. Drawing with charcoal is the most overlooked aspect of painting. Make it a standard practice and the results will be amazing.

Oil Paint- There are only Seven colors that are necessary: titanium white, cad yellow, cad red, yellow ochre, burnt sienna, ultramarine blue and mars black. Purchase artist grade color only. Do not purchase student grade color because there is too much filler in student grade oil paint and the tinting strength is greatly reduced thereby. Go ahead and commit to buying the higher quality paint. The pain brought to the pocket book by purchasing materials may act as a catalyst to make one paint more often.

How to Prepare the Materials

How to prepare the medium- The painting medium is used to thin the paint down enough so that it flows off the brush more easily. Take about 45% linseed oil, 45% stand oil and 10% turpentine. The turpentine is optional. Put them in a small container and mix together. If one adds more turpentine the concoction will dry more quickly. If one adds more linseed oil the concoction will dry more slowly. This medium is self-leveling. That means that by the time the medium dries, the brush strokes will disappear.

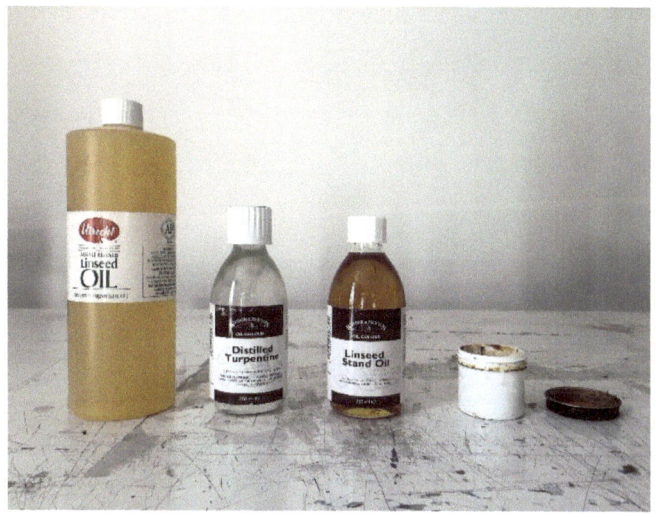

Chapter 2 Step 2 - How to Draw a Still Life

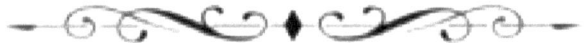

Drawing

Draftsmanship is, by far, the most important aspect of painting. Moreover, using charcoal can take a painting to the next level. Charcoal is the tried and true method of blocking in a painting. It is easily erased and the drawing can be quickly corrected. Time spent on the drawing in the early stages is comparable to investing buckets of cash for retirement; it will compound with interest and pay dividends.

The entire objective of a still life is to create the highest, most realistic rendering possible. After all, a still life is a study designed such that the artist can return session after session without the composition becoming disturbed whatsoever.

For that reason, the method used to create a still life is the sight-size method. Sight-Size is a method of drawing and painting an object exactly as it appears to the artist, on a one-to-one scale. The artist first sets a vantage point where the subject and the drawing appear to be the same size. Then,

using a variety of measuring tools—which can include **levels, mirrors, plumb bobs,** strings, and sticks—the artist draws the subject so that, when viewed from a set vantage point, the drawing and the subject have exactly the same **dimensions**. When properly done, sight-size drawing can result in extremely accurate and realistic renderings.

Some advice on set up. The light source should be strong and from either 10 o'clock or the 2 o'clock. The background should be a dark and neutral color so that the objects can "pop" off the background and give a heightened sense of realism. The artist should select objects that have variation (i.e. dark, light, shiny, dull, rough, smooth, etc). It is good practice to imbue the still life with some sort of narrative as well. Early still-life paintings, particularly before 1700, often contained religious and allegorical symbolism relating to the objects depicted.

With the sight-size method and some set up tips out of the way, lets move right into it. On the next page you will see the set-up with the aforementioned "light box."

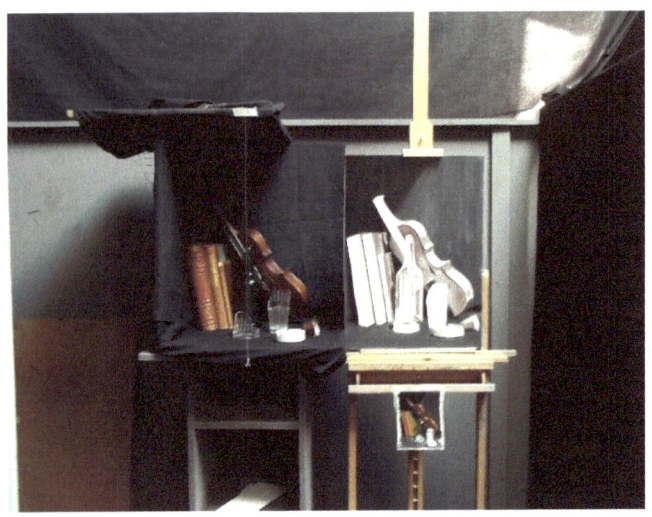

As can be seen, the easel and the "light box" are set to the same height and the board set on the top helps to create some "atmosphere" in the compositions design. The string hanging down there in the center has a plumb bob attached. Using a plumb bob in this manner really aids the artist in determining the vertical. Once the vertical is established by using a plumb bob, it greatly reduces the difficulty in determining angles of objects from the vertical.

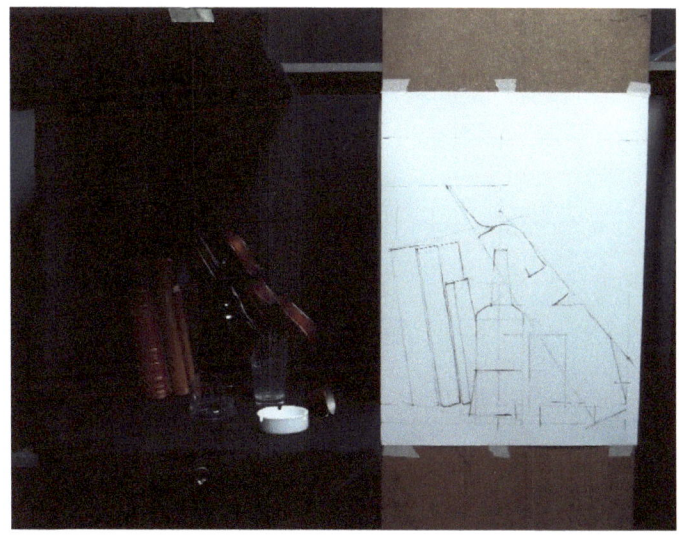

I prefer to begin my still life painting as a drawing on paper. Since we are using the sight size method, it is easy to quickly establish the bases and heights of all the objects. The artist should simply hold the charcoal at the top of an object and then draw a line strait across onto the paper. After each line the artist should take a step back to the viewpoint and make sure the object and the line or point on the paper are at the same height. Consistency is key in still life painting. The artist should place some masking tape on the floor and make all observations from that same reference point. The viewpoint should be 3 meters or 10 feet back from the still life.

After all the bases and heights are established, one should

use the stick of charcoal and measure the widths of the objects. For example, the wine bottle is half the length of the charcoal when viewed from the viewpoint but the ashtray is three quarters the length of the charcoal. Drawing is an exercise in comparison. Making sound comparisons of the objects and their relationships to one another is what creates realism.

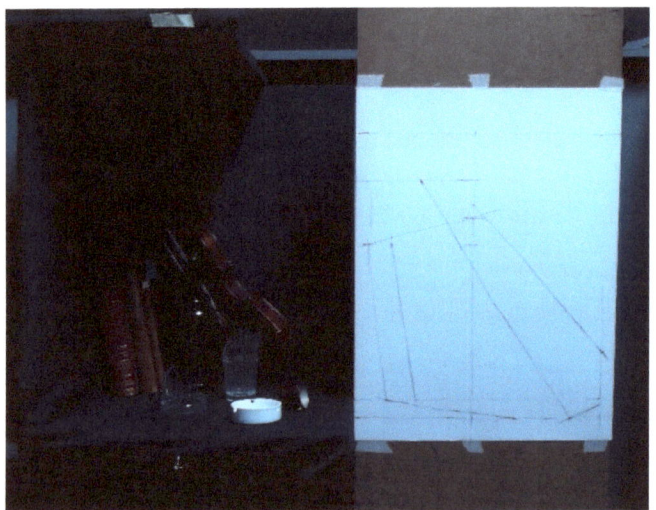

The longest line should be established first. In my example still life, the longest line was the centerline on the violin. As previously mentioned, the establishment of the bases and tops of the objects will mark out some guide points. I knew the top of the violin was above the second book and the bottom of the violin was near the outside corner of the ashtray. After establishing the longest line in the drawing, the artist should move on to the next shorter line. In my example that would be the centerline of the bottle. The artist should continue this process of establishing the proportions of the entire drawing from the longest proportional line to the shortest proportional line.

After each and every single line the artist must stand back on the viewpoint in order to gauge the accuracy. Do not dawdle near the drawing. It is a necessity to back away from the drawing after drawing every single line. The advice to step back away from the drawing after each line was given twice in this paragraph and now here it is again mentioned for the third time: "take a step back to the viewpoint after each and every line drawn."

Take a break for about ten minutes every hour. Each session should last about three hours. After two sessions the still life drawing should be rendered to about the level you see here. If the feet hurt, if the arm hurts, if the eyes are shut and the image is still seen, that is good. Welcome to conditioning.

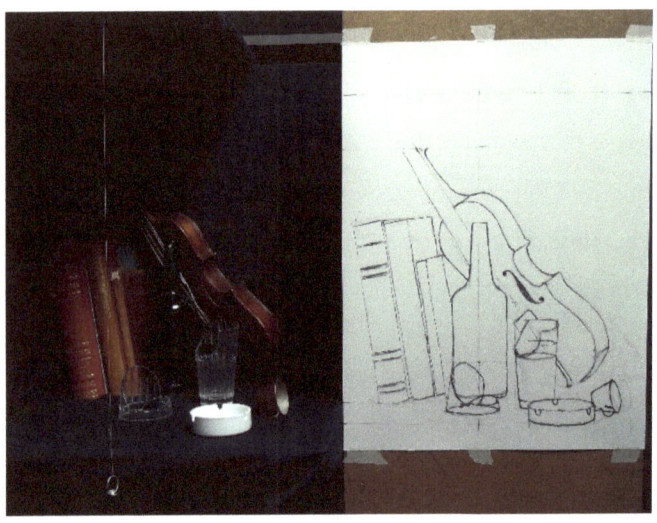

Chapter 3 Step 3 - How to Transfer a Still Life Drawing

How to Transfer a Still Life Drawing

A good practice is to transfer the drawing onto the canvas by the tried and true technique explained below.

Take the drawing of the still life that was completed on the piece of paper. Overlay a nice piece of tracing paper and trace the drawing. Once the drawing has been traced over, the artist should take a safety pin, push pin or thumbtack and make perforations along the traced lines.

Once the entire drawing is perforated, overlay the tracing paper onto the canvas. Use tape to keep the tracing paper in place so that it doesn't shift on the canvas. The next step is to use a piece of vine charcoal and vigorously go over the perforated lines.

The canvas underneath will have dots were the charcoal has pushed through the tracing paper perforations. After this step the artist should line the canvas up next to the still life and go over all the dots on the canvas with charcoal yet again making any corrections that are necessary. A key thing to remember is to continually take steps back from the canvas and use the sight-size method to hone in the accuracy of the drawing working again from the longest to shortest line.

This process of transferring the still life drawing has the added benefit of relieving anxiety about applying paint to the canvas. If the painting starts to go terribly wrong, the artist can simply trash the canvas and transfer the drawing of the still life onto another canvas and start over. After painstakingly creating a deftly accurate drawing, the last thing one would like to see is their canvas turn into a mess with no hope of rescuing their painting. With the capability of quickly replicating the drawing, the painter could do twenty plus copies of the exact same still life (cash register sound).

Chapter 4 Step 4 - How to Complete a Color Study

How to Complete a Color Study

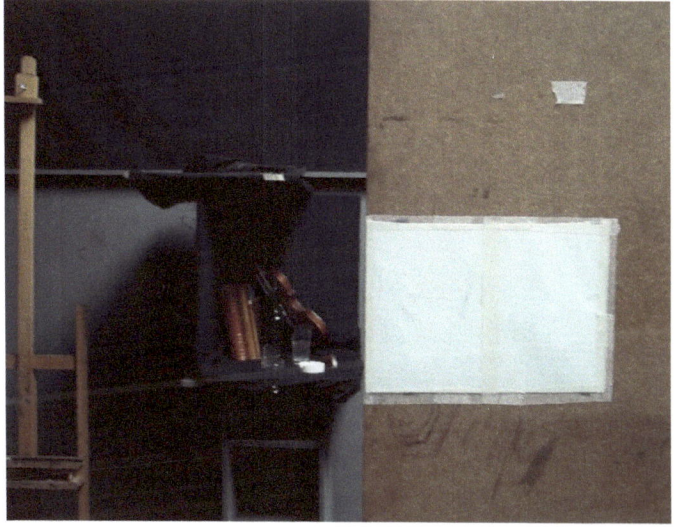

Ok, there is one step to complete before actually applying paint to your canvas and that is to complete a little color study. Take a small piece of canvas paper or a small piece of canvas that has been sized with gesso. Since the size of the still life should be around 18" x 24", the color study should be an 8" x 10".

Despite the small size of the color study, we can still use the

sight size method to draw the still life. The trick is to bring the easel closer to the viewpoint but leave the still life "light box" where it is. The same trick is used by children that hold up their thumb, and make it the same size of their friend in the distance; or a silly tourist that acts like they are holding up the leaning tower of Pisa.

With all the hard work put into the previous drawing, it should be quite easy to draw yet another albeit smaller drawing of the still life. After the drawing is completed, whip out the palette and start dashing in some color in a single layer that closely resembles the still life color and makes a few notes about the color combinations.

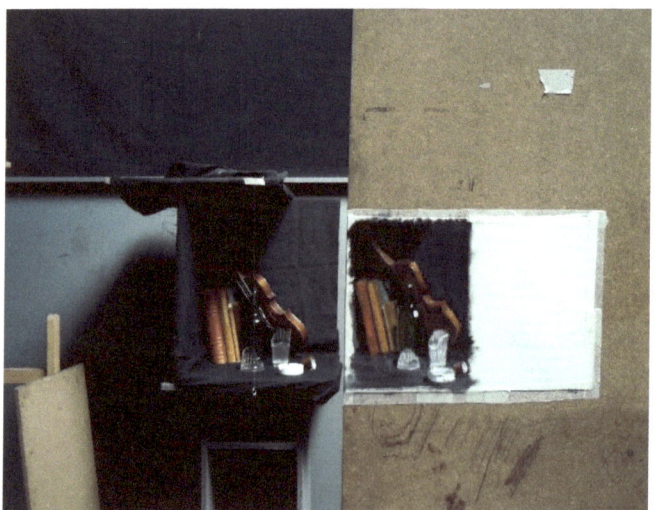

Chapter 5 Step 5 - How to Start the Painting

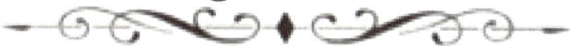

How to Start the Painting

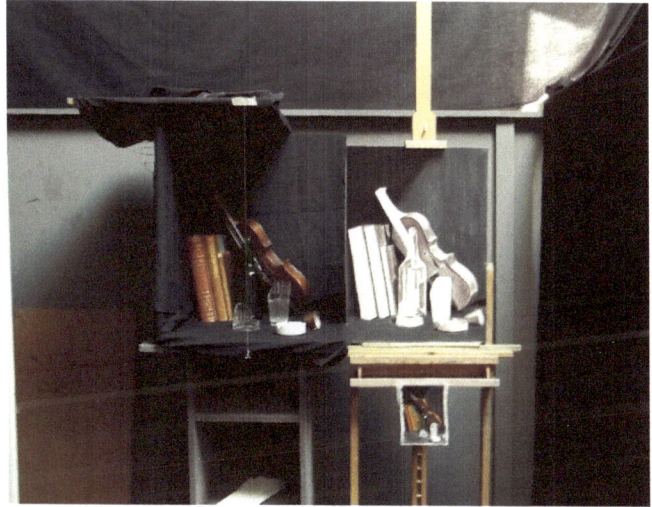

Ok this is the moment of truth and it is time to put actual paint on the final canvas. This is a long time coming indeed. Since we are using the 24-hour gauge in this guide, let us recap the time spent so far.

The artist should spend at least six hours working on the charcoal drawing, about an hour tracing the drawing and transferring it onto the final canvas and about three hours on the small color study prior to beginning to paint on the final canvas. That is a total of 10 hours.

The very first application of paint should be to establishment the darkest values in the composition. In my example, that would be the background. If lighter colored material is used in the background drapery, then the darkest value will most likely be the immediate shadow directly underneath one of the objects.

Once that darkest value is found and established on the canvas, move onto the next lighter value until the entire background is painted.

During this entire process of the first block in with paint, be sure to thin down the paint so that it is almost like watercolor paint. Simply use the painting medium described at the beginning of this guide. Since the color study was already completed, the first layer of paint should go on very quickly. Remember to step back after every brushstroke. The process is always the same no matter if it is charcoal in the hand or a paintbrush. Taking frequent steps away from the canvas allows the artist to see. One other point is to take

frequent breaks. I know it was already mentioned but take at least one ten minute break every hour and limit painting sessions to three hours total. That is a necessity for the mind and the eye. After the first painting session the Still Life painting should be taken to about the level shown below. Estimated work time elapsed: 13 hours.

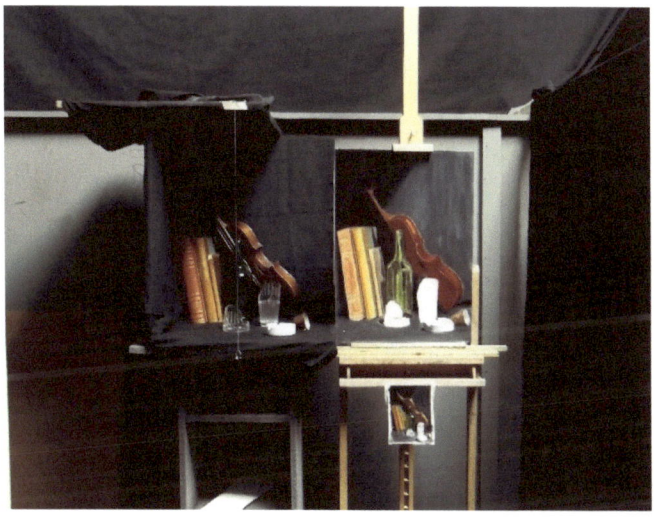

Chapter 6 Step 6 - Develop the Painting Further

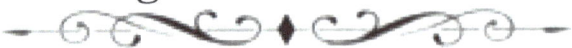

How to Develop the Painting Further

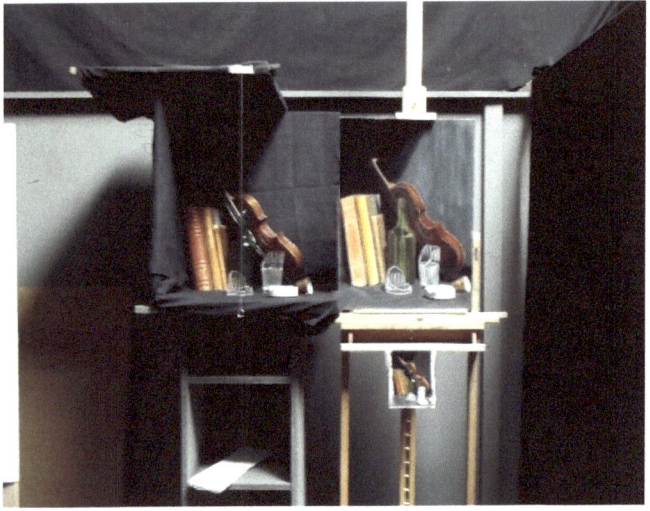

Make use of the color study that was completed by taping it to the bottom of the easel for reference.

At this point the artist should be very well acquainted with the overall composition, values of all the shadows and objects, the interplay of refracted light bouncing between objects and the subtle relationships that are only discovered after the arduous task of observing the elements that make

up the process of still life painting. I have to let the cat out of the bag; the only way to gain a high level of artistic execution in painting is to be able to draw like mad.

Since the artist has made great observations during the practice and science of drawing the still life, added to that drawing by executing the color study, advanced by blocking in the transferred drawing with the first indications of the value relationships, now is the time to develop the painting further.

The painting should have been able to dry a bit since the last session, the painter should begin again in the darkest value and discover what kind of color that darkest value has. The darkest values or shadow shapes are often either warm or cool in nature and imbuing these shadow shapes with the correct temperature will give the still painting the life it deserves. The artist can apply a thin layer of paint as a wash over the previously dried paint in order to achieve the desired illusion. When the paint is thin, light actually can penetrate through the layers of paint and bring light into the darkness.

Continue this process for each area of the canvas always beginning each session in the darkest value and working towards the lightest value in the composition.

It is best to break down the development of the painting into two, three-hour sessions. Take ten minute breaks every hour. The reality will strike the artist that during these sessions actually very little paint is applied to the canvas but rather the majority of the time is spent looking intently at the still life and making observations and comparisons with the canvas from the reference point previously placed upon the ground. Total time elapsed: 19 hours.

Chapter 7 Step 7 - How to Finish a Still Life

How to Finish a Still Life

Ok, this is it. There are two sessions left and this is where the magic happens. At this stage the artist has dedicated a lot of time and energy. The drawing is astute, the paint has been applied thinly with restraint and now the application of perfectly applied thick, icing-like highlights with accentuated brush strokes will set everything off. I am talking about taking ten minutes shaping the perfect glob of paint on the brush and practicing the stroke about a dozen times before the brush makes contact. Take time to look at the highlights and discover the iridescence of each one. It is extremely uncommon for a highlight to be pure white. Look at the highlights from the observation point and find the secret formula.

Often times there are optical illusions. In my example, the green wine bottle had the weirdest alizarin crimson or red iridescently tinged highlight. That could have been from the

neighboring violin or it could be that highlights tend to gain the color of their complimentary color (i.e. opposite side of the color wheel). In other words, an object that is green will have a highlight that is a modicum red. Perhaps it is refraction of the physical universe or perhaps it is refraction in the psychic universe; the artist should decide. Total elapsed time: 24 hours.

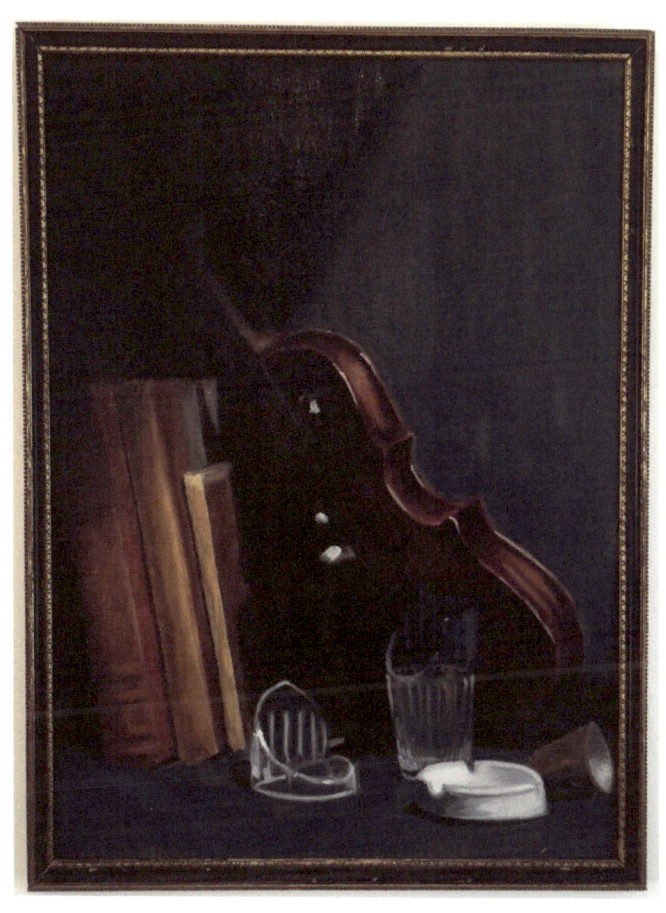

Chapter 8 Conclusion

Conclusion

Many fine art instruction guides go into all kinds of details and exercises. This guide and all my other fine art guides are to the point. This is by design. I think it is strange to sit around and read about art instead of actually making art. It is similar to sitting around and watching sports as opposed to playing sports. Of course we can learn a lot and enjoy our time while in repose but there has to be a certain level of exertion in order to be a creative maniac. Man is measured by his enemy; his worst, himself.

It is time to make some moves. Included in this guide is a list of supplies needed, there is instruction on set-up, advice on drawing, guidance on transferring the drawing, pointers on wielding a paintbrush and guidelines on finishing a fine Still Life. No amount of reading will prepare the artist for painting. No author can paint a painting for the reader. The reader must commit to the endeavor by his or her own free will and accord. I have but one more statement and I know

that is controversial. Many believe that painting from a photograph is acceptable. Still others believe that it is acceptable to use a projector in order to create an accurate drawing. Perhaps we are all guilty of committing this high treason. There is no practice that will disable the faculty of drawing faster than technological crutches. Go for the glory and draw with your head, heart and hands.

"The only source of knowledge is experience." –Albert Einstein

Please rate and write a review of this book online.

Acknowledgements

I would to thank my mentor Mr. Doran for all of his interesting insights and good advice. Capitalism Forever!

So you made it through this little book? I am very glad that you did. Hopefully the instruction given will be useful. If you have particular questions, please find me online for additional resources. I look forward to seeing what will be created from this creation. All of my artwork is available for sale online as originals or as prints, along with painting tutorials, recommended products, and more.

My Website: http://www.artworkbyjj.com/

Facebook: https://www.facebook.com/ARTWORKBYJEREMIAHJOLLIFF

Blog: https://jjolliffblog.wordpress.com/

Twitter: https://twitter.com/jeremiahjollif

Youtube: https://www.youtube.com/channel/UCsauBxqWjjow6bCKl7DgRHA

LinkedIn: https://www.linkedin.com/in/jeremiahjolliff

Instagram: https://instagram.com/jeremiah_jolliff/

Pinterest: https://www.pinterest.com/jeremiahjolliff/

Further Reading and Bibliography

Carlson's Guide to Landscape Painting
By John F. Carlson
(C)1929
>This is the definitive guide to Landscape Painting that the serious painter should already have in their collection. If they do not have it, then they should go buy it immediately.

Hamlet's Mill, An Essay on Myth and the Frame of Time
By Giorgio de Santillana and Hertha von Dechend
(C)1969
>This is a great book that will illuminate the mind to the natural events that gave birth to this era of increased productivity.

Landscape Painting
By Asher B. Durand and Birge Harrison
(C)2013
>A collection of Letters on Landscape Painting from Asher B. Durand with an original copyright of 1855 and the second part of the book is a reprint of Birge Harrison's book entitled *Landscape Painting*. This book is only for the individuals who have been initiated by their artistic practice out in nature.

The Practice & Science of Drawing
By Harold Speed
(C)1924
> A heavy duty treatise on the craft of drawing and its more esoteric applications. Fortunately this is a mandatory book for the serious artist engaged in real life art making.

Oil Painting Techniques and Materials
By Harold Speed
(C)1924
> This is the unofficial follow up and sequel to the aforementioned book by the same author.

The Practice of Oil Painting and Drawing
By Solomon Joseph Solomon
(C)1911
> Solomon Joseph Solomon's tour de force; before the modern artist and charlatans ransacked the philosophical house of painting, S.J.S. hid the jewels away in this work in the hopes that one day more illuminated benefactors would recover the craft of painting.

www.ingramcontent.com/pod-product-compliance
Lightning Source LLC
Chambersburg PA
CBHW040817200526
45159CB00024B/3014